CELTIC DESIGN

MAZE PATTERNS

AIDAN MEEHAN

With over 200 illustrations

THAMES AND HUDSON

British Library Cataloguing-in-Publication Data
A catalogue record for this book is available from the British Library

ISBN 0-500-27747-8

Printed and bound in Spain

Contents

[5]

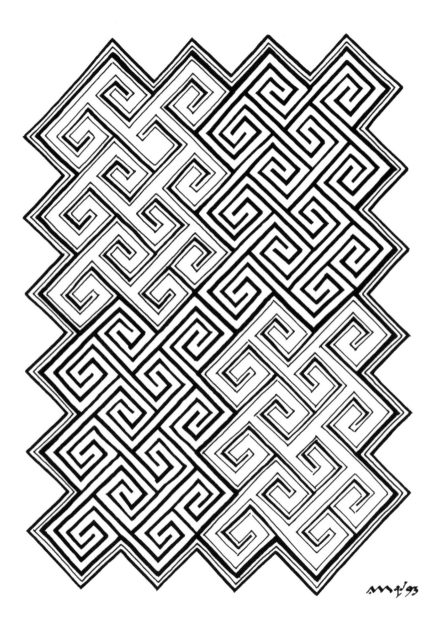

[6]

INTRODUCTION

 ELTIC MAZES are straight-line spiral patterns originating in prehistory and found all over the world, but nowhere developed with such variety as in Celtic art from about 650 AD, when they began to appear in manuscripts, on sculptured stones and metal – work, and became an essential part of Celtic art to this day.

[7]

Introduction

New readers will find this book
an ideal introduction not only
to the rest of the series but to
Celtic art at a beginners' level.
The designs published here are
mostly easy enough for first-
timers to reproduce. Most are
a matter of connect-the-dots.
Yet even though these mazes are
simple to do, the secret of
their construction is not so
obvious.

I aim here to give the join-
the-dots method used by the
makers of these patterns from
earliest of times, while show-
ing how they may be interpreted
as a species of maze symbol,
rich in myth and history, full
of meaning and of magic.

[8]

But first, to explain the name Celtic Mazes. When James Romilly Allen first analysed these patterns in 1885, he called them "key pat – terns" to distinguish them from fret, meander and other such sorts of ornament. He observed that in Celtic art the patterns tend to be laid out on a dia - mond celled grid fitted into a rectangular frame which then cuts the grid into half cells at the edges. In these edge tri – angles, the commonest treat – ment looked to Allen rather like a key fitting into a lock. And so he called them key patterns. However, we rarely now see the kind of key Romilly Allen had in

mind - the Apostle's key. He
could as well have called it L-
pattern, or walking-stick
pattern. The term key pattern is
as arbitrary, and does not des-
scribe the pattern properly; there
are too many examples based on
the square grid that have no
edge triangle; others based on
a diagonal grid are not fitted to
a rectangle but float unframed,
without edge triangle or "Key".

Another problem I run into
is this: often when people hear
the word "key" they think of it as
meaning the "clue" to some secret
or code. They are sceptical about
the explanation that it is the
shape of the edge filler which is
like a key in a lock. So, the name

coined by Allen is inaccurate as a
classification, misleading as a
title. As for distinguishing the
Celtic from the Greek or Chinese
fret pattern, these also have L-
shaped "keys", so the distinction
is lost on me. For these reasons,
I propose to refer to the patterns
we shall be exploring in the pages
to come as *Celtic Maze Patterns*.
Calling it *Maze Pattern* gives a
clearer idea of what it looks like;
calling it "Celtic" distinguishes it
from other types of mazes,
meanders, frets or puzzles.

Celtic mazes, unlike modern
mazes are not full of cul-de-sacs,
with false turns or central goal.
Rather, as we shall see, the Celtic
mazes with their windings are

multi-choice mazes, which,
though enclosed, satisfy a
general, dictionary definition of
the term which I propose to use
for them, whereby the word
"maze" is given to mean:
 " 1. An intricate network of
 paths or passages."
Or, the word may be taken to be:
 "2. A state of bewilderment"
– in which the unwary may find
themselves, trying to construct a
Celtic Maze Pattern without the
right method. But I think we
will not use this second meaning
except in the sense that Celtic
maze patterns are truly *amazing*.

PRIMITIVE GEOMETRIC PATTERN

ROM THE LATE STONE AGE and during the Bronze Age, the type of ornament used is called *Primitive* meaning, *first* : " of or belonging to the first age, period or stage; pertaining to early times; earliest, original". Romilly Allen has traced the origins of Celtic design to this primal language of pattern. It is the simplest form of pattern, and the most enduring.

[13]

Chapter 1

Romilly Allen discovered that this primitive pattern was based on the symbol of two straight lines ending on a point, like the letter V; two sides of a triangle. He called this symbol by its heraldic name, the *Chevron*, a familiar device on the shield of many coats-of-arms, *fig.1a*. A row of chevrons repeated side-by-side produces a *Zigzag*. Two chevrons, when stacked apex-to-apex make a diagonal cross, in heraldry known as the *Saltire, fig. 1b*; joined base-to-base, two chevrons make a diamond shape, or *Lozenge , fig.1c*.

Fig. 1 Chevron, Saltire and Lozenge.

a Chevron. b Saltire. c Lozenge.

d Chevron row repeat.

e Saltire row repeat.

f Lozenge row repeat.

Fig. 2 Saltire Tile Border.

a Lozenge border.

b Saltire border.

c Saltire tile border.

The saltire can be defined more clearly by adding dividing lines between units.

Fig. 3 Hexagon Border.

a Hexagon border.

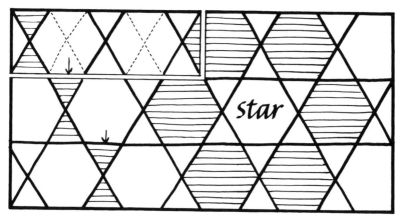

b Hexagon border in vertical repeat.

The hexagon is arrived at by leaving out every other unit of the saltire border. The star comes from staggering the successive rows of hexagons, so each row is off-set by one unit to the side.

Fig. 4 Beaker Urn from Laken
 Heath, Suffolk, 2,000 BC.

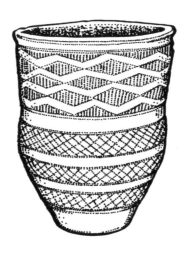

The Laken Heath beaker has
rows of lateral chevrons and bands
below alternating between plain
and crosshatched. The crosshatch
naturally gives rise to the saltire-
and-lozenge pattern, fig. 5.

Fig. 5 Saltire-and-Lozenge.

a Saltire.

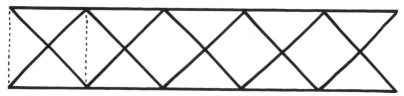

b Lozenge.

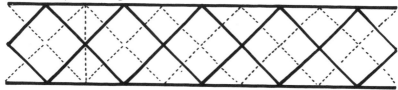

c Saltire-and-Lozenge.

d Saltire-
 and-
 Lozenge;

or is it
four
saltires?

The importance of this kind of
pattern to the Celtic art of later
times impressed Romilly Allen:
"The decoration consists
entirely of straight lines
running more often diagonally
than either horizontally or
vertically. The same preference
for diagonal lines will be
observed in the key patterns
of the Christian period, and
led to those modifications
of the Greek fret which are
characteristically Celtic."
It interested him that the system
could be reduced to the chevron:
"Of the hundreds of sepulch-
ral urns of the Bronze Age
that have been found in
Great Britain, no two are

exactly the same either in size,
form, or decoration. The ferti-
lity of imagination exhibited in
the production of so many
beautiful patterns by combin-
ing diagonal straight lines in
every conceivable way is really
amazing. On examination it
will be found that, complicated
as the patterns appear to be,
the chevron or zig-zag is at the
base of the whole of them."
Romilly Allen went on to
define a principle of geometrical
ornament which also applies to
Celtic patterns: for each pattern
composed of lines there is a corres-
ponding pattern in which bars of
uniform width are substituted
for lines.

Fig. 6 Line-to-Bar Treatment.

a Zigzag line border.

b Zigzag bar border.

c Surface pattern produced by repeating line or bar border.

Fig. 7 Shading Treatments.

a Zigzag border.

b,c Different ways of shading.

d Alternate direction hatching
so zigzag does not get lost.

Fig. 8 Bar Zigzag Border,
 Shaded Treatment.

a Bar zigzag border.

b The same, shaded.

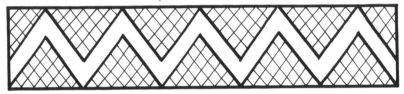

c Overall bar zigzag panel,
 shaded.

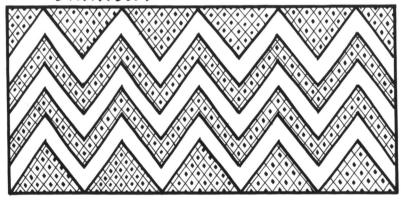

Primitive Geometric Pattern

Fig. 9 Herringbone Pattern

a Chevron turned sideways.

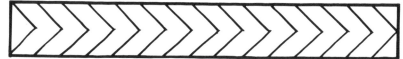

b The same, shaded.

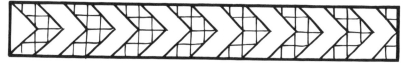

c Herringbone border.

d The same, shaded.

e "Fir tree" f "Ear of corn"

↑ up ↓ down

Fig. 10 Triangle Grid Pattern.

a Chevron border. The same, shaded.

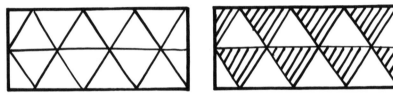

b Chevron border mirrored on horizontal axis, or triangle grid.

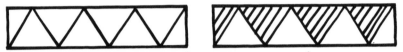

c Triangle grid overall pattern.

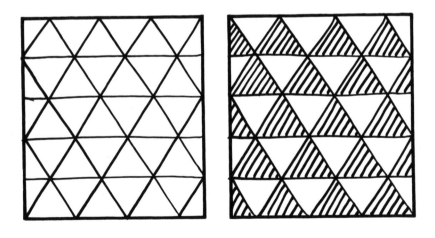

Fig. 10c, reads as a row of lozenges divided centrally; saltires, with a central division; a row of hexagons with diagonals; a plane-projected cube moving through a series of positions in time and space: all these at once! Stone Age people could sense motion in such a pattern, as can we. Read the pattern as triangles; focus on each, one after another. The brain can scan it as a series of frames, as in a video image of the one triangle roving throughout the border. Shading adds the sense of depth: now a white triangle seems to float above the ground. Such magic power of line inspired the first maze makers.

Fig. 11 Bar Lozenge, Saltire and Chevron Borders.

a Bar lozenge border.

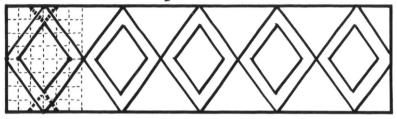

b Bar saltire border.

c Bar chevron, point to point.

Fig. 12 Bar Chevron Panels.

a Bar chevron, point to point.

b Bar chevron, points apart.

Fig. 13 Lattice-Work Patterns.

a Line lattice or saltire grid.

b Bar lattice.

Primitive Geometric Pattern

Fig. 14 Saltire-Derived Patterns.

a Saltire tile border.

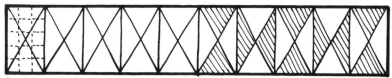

b Bar saltire, tile panel.

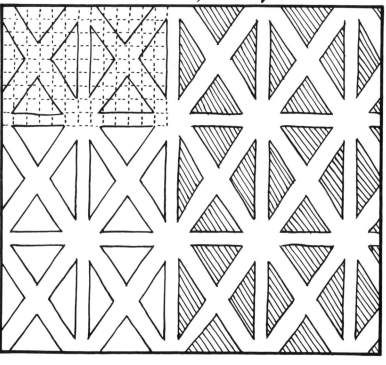

Fig. 15 Pattern from Newgrange, Ireland.

The pattern on this stone from the chamber at Newgrange may be traced by a continuous line, a or b.

a

b

ORIGIN
OF
MAZE PATTERN

AZES ARE CLOSELY AKIN to spirals, both in form and meaning. The oldest maze we have may well be that seven-fold spiral engraved on a mammoth tooth found at Mal'ta (fifty-five miles north-west of Irkutsk). Jill Purce called this piece "the first spiral known in the history of art, a Paleolithic talisman from a ritual cave burial in Siberia".

Fig. 16 Spirals from Mal'ta,
 Siberia, c. 24,000 BC.
a Spiral panel.
b Reverse, showing three snakes.

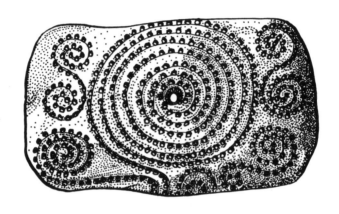

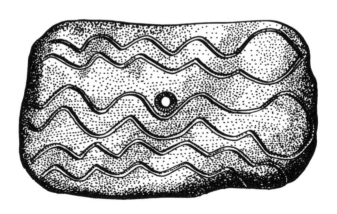

The Mal'ta spiral is the work of Cromagnon Man, the first artist, who ranged west from the Ukraine to the Dordogne caves, east to the Urals, north to Alaska, and south to Australia by about 20,000 years ago. The Siberian Mammoth Hunters, lacking caves, lived in hide tents weighted with huge tusks against the scouring wind. Ivory was their medium. One figure described by Jacquetta Hawkes shows "a tailored single piece hooded garment made from skins, the fur turned to the outside". Such a figure wielding a flint awl, perhaps a shaman, worked the talisman of Mal'ta, the first maze.

Chapter 11

Cromagnon originated not only figurative art but also the first religion. Perhaps the earliest icons are the half-bird, half-woman ivory figurines of Mal'ta. The sign of the chevron was adopted as the sign of the Bird Woman. We can trace the westward migration of this association of chevron and water-bird down to the end of the Old Stone Age, say 15,000 BC, to Mezin, in the upper Desna basin, Ukraine. Here we find highly schematic bird-woman forms clearly descended from the Mal'ta type. The chevron dominates the images. Where once the chevrons cut on wings or body might be taken for fur or feathers, now they have taken on a life of their own.

Fig. 17 Mammoth - Hunter Icons of Bird Woman.

a From Mal'ta, Siberia, c. 24,000 BC.

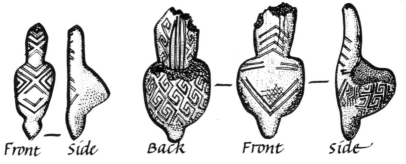

Front Side Back Front Side

b From Mezin, Ukraine, c. 15,000 BC.

Chapter 11

Fig. 18 The Mezin Bird-Woman Pattern Reconstruction.

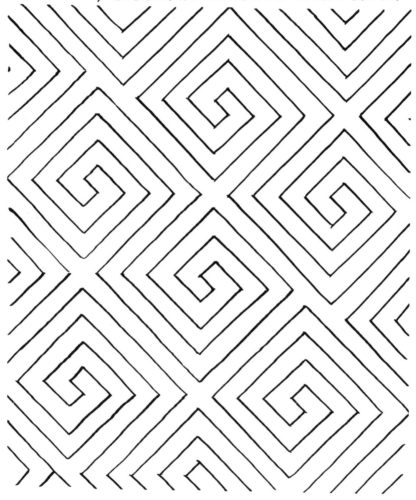

The chevron signifies the Goddess
for, as Marija Gimbutas put it:
"Graphically, a pubic triangle
is most directly rendered as a V."
However, children often draw the
sky bird as a V. Who does not feel
a sense of religious awe at the
sight of the V-formation of birds
in flight? To a hunter, that
chevron of geese returning north
is also loaded with significance.
So, whether as a shorthand sign for
the pelvic girdle of the woman, or
as the pattern of the waterbirds in
flight, or as a symbol of the high-
est as of rafters meeting in the
ridge pole of a roof, the chevron had
become the symbol most particular-
ly associated with the Bird Goddess
of the Middle Stone Age.

As a symbol, the chevron may also be considered as being intelligible in and of itself. Strictly defined, a symbol refers to its own content, rather than something outside itself, such as a word - "bird" - or letter - "V". The chevron contains points and lines; describes an arc with centre and radii; defines an apex, an angle; relates unity, one point, and duality, two point; expresses the relation between one dimension, line, and two dimensions, triangle, but stops short of completing the triangle. It has convergence and divergence; conjunction and division. It opens and closes. It bends. It ascends and descends. It begins, but does not end. Thus the symbol can be explored to infinity.

[40]

The transition from chevron
patterns to spiral maze patterns
may be seen beautifully illustrat-
ed in the decoration on the Mezin
bracelet or armband, overleaf.
The design may be seen in two
ways. As a band, the pattern
alternates between spirals and zig-
zags, two of each, spiral opposite
spiral, zigzag facing zigzag. It
is a beautifully balanced, four-
fold design. Yet, when we view
the plan of the band when it is
flattened out as a border, the
decorated surface is interrupted
by two distinct breaks, dividing
the whole strip into a symme-
trical threefold arrangement.

Fig. 19 Mammoth Ivory Arm-
band, Mezín, c. 18,000 BC.

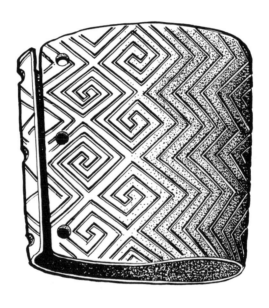

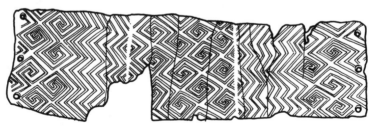

The MAMMOTH hunters' MAZE

N THE MAMMOTH IVORY band from Mezin we find the earliest instance of an *overall* maze pattern. Approximately 18 cm in length, fitted with lacing holes, it wrapped around a graceful Cromagnon upper arm, in four panels. The laced side and the opposite face are engraved with meandering double spirals, which dissolve into vertical zigzags on either side.

Fig. 20 Mezín Armband, Construction.

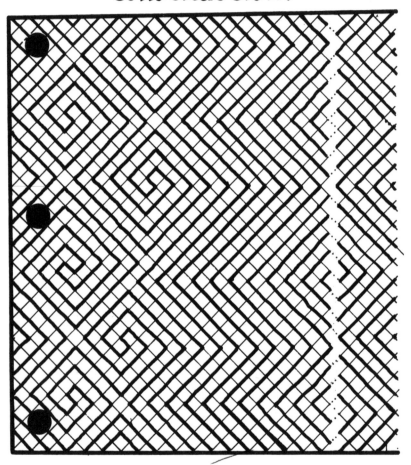

We have already seen that the chevron angle is the basis of Primitive Geometric Pattern. The grammar of ornament that flows from that symbol, along with the saltire cross and lozenge symbol, allows an endless variety of patterns as if automatically. Automatic, because this system works so simply it requires no calculation and so is a spontaneous form of expression. Somehow it works with the way the brain works. The first symbol gives rise to two, and from various repeats and permutations, endless variety results, forms multiply and unfold in the same way as they do in nature.

Fig. 21 Angular Spiral, Single and Double.

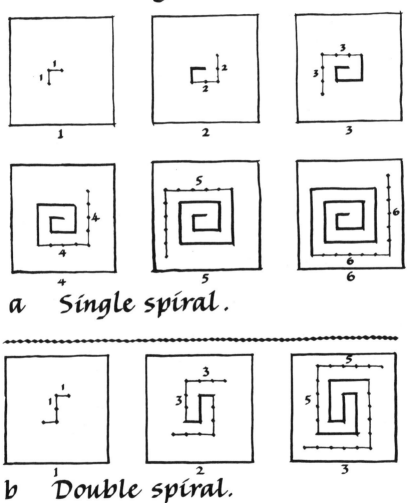

a Single spiral.

b Double spiral.

[46]

The Mezin armband sandwiches zigzags between spirals, both chevron-based. Zigzags repeat chevrons in one dimension, a line: 1+1+1 The spiral is a series of chevrons: 1+2+3+4..., expanding around a spiral, alternating on either side of an axis line. A spiral is, like a chevron, dimensionally ambiguous. If you cut a spiral out of a scrap of leather, the surface becomes a coil that may be unwound into a surprising length of useful thong. So the spiral divides up the surface while keeping it whole. It raises the matter of the relationship between different dimensions: line and surface, direction and field.

[47]

Chapter III

In the Mezin armband there is a hair line break in the pattern between the zigzags and spirals. The engraving stops at this strip. Chevrons bracket the split, forming a column of lozenges down the middle, one side slid along a notch, offset along the rift. The Mezin artist in this way marks where the zigzags transform into spirals, but also marks *how* this can be done: the spirals are directly constructed from concentrically nested diamonds split and offset one unit, a good example of the way form conveys information.

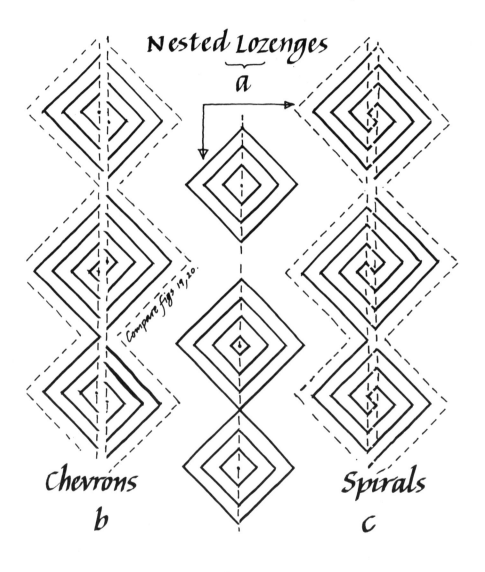

Nested Lozenges
a

Compare Figs 19/20.

Chevrons
b

Spirals
c

Fig. 23 Double Spiral Border, Diagonal Repeat.

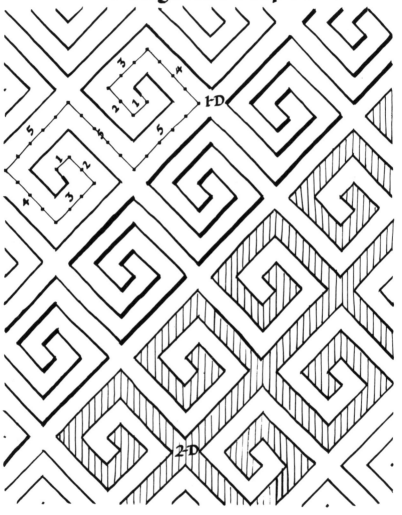

Fig. 24 S-Scroll Unit, Diagonal Repeat.

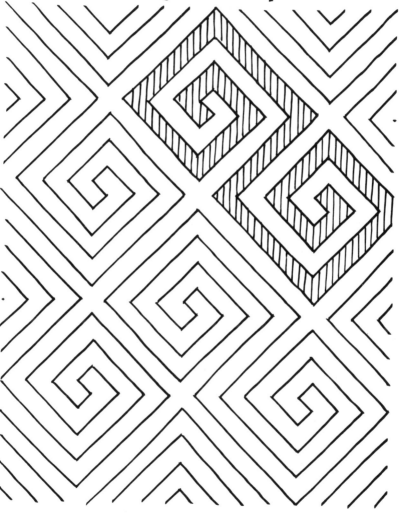

Fig. 25 Decorated Goddess, Hungary, c. 5000 BC.

THE MEANING OF THE MAZE

E HAVE SEEN HOW the elements of primitive geometric pattern may be interpreted either as signs or as symbols. In this chapter we will be looking at the signs of the goddess that often accompany the maze patterns on figurines and models of temples. Also, we should look at the the continuity of association of maze and the goddess through millennia.

[53]

Fig. 26 Signs of the Goddess.

Chevron.	Double coil.	Ram's Horn.
Saltire.	Net.	Hourglass.
Lozenge.	M-sign.	Y-sign.
Triline.	W-sign.	Bird's foot.
Comb.	S-sign.	Chequer.
Single coil.	Butterfly.	Lens.

The Butterfly sign for the labia is a
symbol of parturition; Lens and Loz-
enge signify the womb or vagina; the
Ram's Horn is a sign for the womb
with fallopian "horns"; the Hour-
glass symbol of conjunction and
separation denotes the female form;
the comb is a metaphor of cosmic or-
der, and depicts rainfall, waters; the
M-sign is associated with the mask of
the bird goddess; Net and Chequer
symbols are cosmograms of mater-
ial existence, time and space; the Tri-
line symbolizes threefold nature;
The W- or Omega sign may refer to
breasts; spirals and S-signs sym-
bolize expansion or contraction,
rhythms of polarity and attraction,
oscillation or cyclic periodicity,
cause and effect.

[55]

Fig.27 Examples of Goddess Signs.

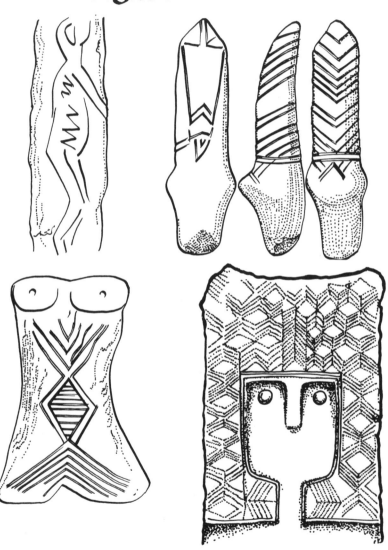

On the opposite page among the
examples of goddess signs we
find a figure with zigzags on its
belly or flank. It comes from the
thirty-thousand-year-old site of
Cromagnon, France. It seems to
have one arm raised, left, top.
Next to it is a bird-woman figure
from Mezin, 18,000~15,000 BC, shown
in three views, front, side and rear.
The front shows a torso and pubic
V; the rear shows chevrons that
could be read as hair or feathers,
tail bone or duck tail. Bottom left
is a female figure, a torso, with
chevrons above and below a lozenge
signifying the abdomen or womb.
Last, from about the third millen-
nium, a late Neolithic owl goddess
with chevron-based hair-do.

Chapter IV

The style of decoration as applied to the figures of the Bird Goddess developed from the Old Stone Age on, and evolved into maze pattern. The form of the maze is directly linked to the art of that ancient, female-centred epoch. The figure of the ← goddess was the primal religious icon, decorated with signs such as we have seen, and patterns based on the chevron, as the funda-mental female sign. The promin-ent parts of the body were often decorated with chevron-based signs. For example, the lozenge was placed on the belly, chevron on pelvis, meander on buttocks, ← etc.∘ These signs were universally understood as Goddess emblems.

→ As a body decoration, the spiral is
an energy vortex. It used to be ←
thought the spiral arose out of
the observation of the spiral in
nature, such as shells, flowers and
especially in the movements of
water. Water and life are so
closely related that the element
of water was understood to be the
medium through which life, and
therefore the goddess, pervades
and flows throughout nature. The
Goddess in particular was con-
nected with the waters that break
at birth, the secretions of arousal,
of tears, of exertion, the flow of
milk, the flow of blood. Like the
spiral, the zigzag signified water
too, that of the cosmic womb
from which this world was hatched.

[59]

Fig. 28 Goddess Shrine,
Romania, c. 5000 BC.

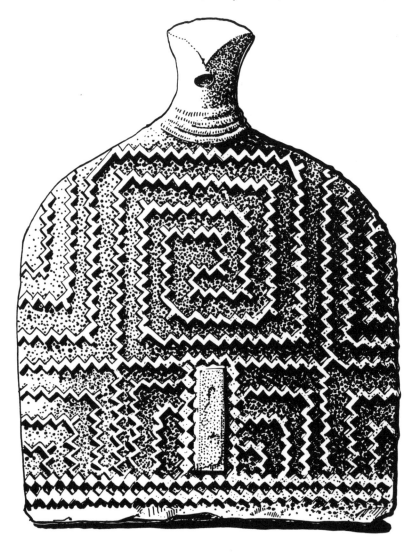

Folk who revere the earth as the ♀
goddess see certain springs as
life-giving waters flowing from
her body : hills as her breasts or
belly, grain as her hair, caves as
her womb. This is why many ♀
river names are also goddess
names. The Paps of Anu, twin
mountain peaks in Ireland, are
named as the breasts of the
goddess, Anu. The river Shannon
sprang from a holy well in response
to the goddess Shannon, "The Old
One". Likewise, Newgrange in the
Boyne Valley was the palace of
Boand, from whom the rivername
Boyne is taken. She approached a
forbidden well which then over-
flowed; thus the Boyne was born.

Fíg. 29 Court Caírns, Ireland, c. 5000 BC.

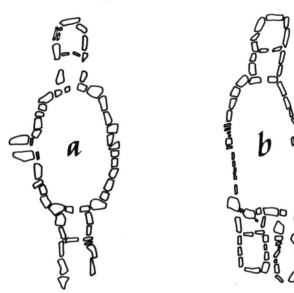

a Ballyglass, Co. Mayo.
b Deer Park, Co. Slígo.
These tomb plans portray the goddess, pregnant and standing up.

Fig. 30 Court Cairns, Ireland, c.3000 BC.

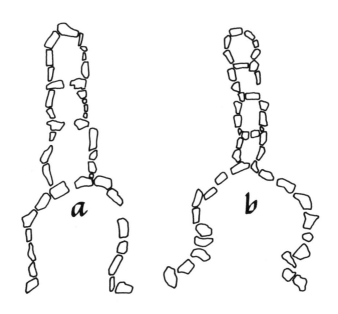

a Creevykeel, Co. Sligo.
b Ballymarlagh, Co. Antrim
These represent the birthing goddess.

Chapter IV

"In western Europe where large
stones were used in grave archi-
tecture, the body of the
Goddess is magnificently
realized as the megalithic tomb",
as Gimbutas said. In the court cairns
of Ireland the entrance to the tomb is
clearly designed as the entrance to
the womb. This is also the case at
Newgrange, where the huge man-
made mound itself is shaped like a
pregnant belly; and the plan of
the tomb is that of a figure
with arms outstretched. This
figure with arms outstretched may
be compared to that with wide-
spread legs forming the "court" of
the court cairn at Creevykeel, the
pregnant profile of the plan at Deer
Park, or with arms akimbo, Carrowkeel.

[64]

Fig. 31 Irish Passage Graves,
 Carrowkeel, 3000 BC.

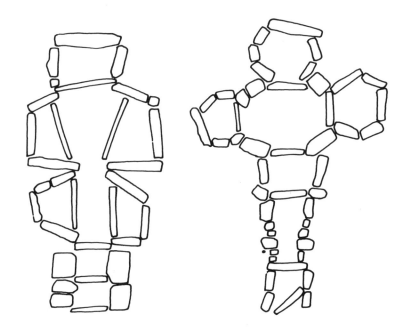

Chapter IV

⌖ Finding mazes at megalithic tombs led to the idea that the basic maze is a symbol of death, as at Crete. But if, as we have seen, the maze originated as a goddess sign, and at tombs built to remind us of the body of the pregnant, birthing goddess, it more likely means the way through death, rather than to it. Just as the journey⟵ through the birth canal leads to life, the maze may be taken as a model of the birthing journey; as a reminder that the narrow, winding path out of this life into an entirely different state is hidden from the living as this life is hidden to the child before birth.

Fig. 32 Labyrinthine Patterns, Gavrinis, Brittany.

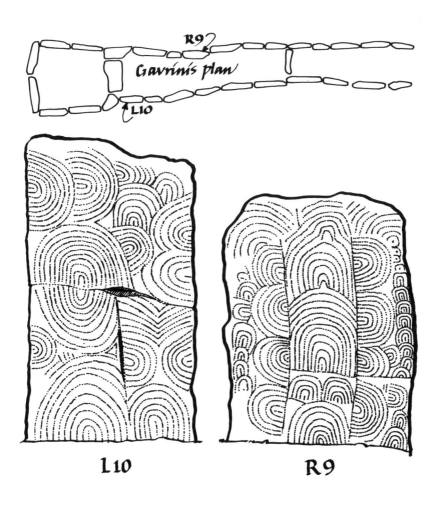

L10 R9

Chapter IV

Marija Gimbutas reads the signs of the "Cathedral of Regeneration," as she called Gavrinis, as patterns of life-renewing energy rising out of the depths: in fact the site *is* surrounded by water. And, significantly, like New-grange, Gavrinis is aligned on the winter solstice, the rebirth of the sun.

↳ If we look at Gavrinis patterns in this light, the ridged and folded patterns carved into the passage walls of the tomb take on a less abstract appearance. If indeed they echo the shapes of breasts and bellies, etc., we can accept the definition of labyrinth as "regenerative womb", especially in the instance of the megalithic tombs.

[68]

✦ Some of this original meaning survived in the Greek word for maze, at least to Robert Graves who gives *labyrinth* as "mountain" or "subterranean cave".

The usual definition is "place of the double-axes" (from *labrys*, double-axe). Greece got the labrys from then-ancient Crete. It surely looked like a double-axe, but in origin we recognise the labrys as the emblem of the goddess in the form of the butterfly. Thousands of years before metal axes, it was painted on a clay dish from Bohemia, in the centre of a whirling pentagon of double spirals – itself a kind of maze pattern: the butterfly is the perfect allegory of metamorphosis – imago from chrysalis – and rebirth.

[69]

Fig. 33 The Butterfly.

a Pottery Dish, Statinice, Bohemia, c. 5000 BC.

b Cretan goddess holding butterflies (double axes), c. 2000 BC.

c Celtic coin, c. 770 BC.

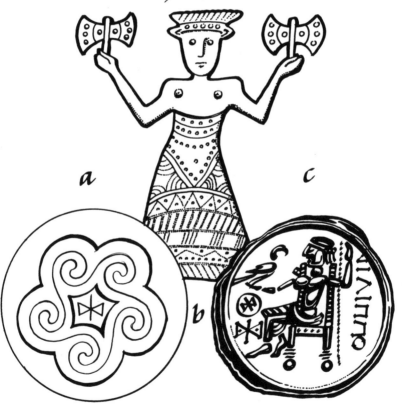

a

c

b

THE CAMONICA VALLEY MAZE

1N THE ICE-PLANED rock face of the Val Camonica, near Lake Garda in the Alps north-east of Milan, thousands of petroglyphs record scenes of every day life of early Celtic hunter-farmers who lived in the valley. Among the carvings are a variety of labyrinth designs, including one like those on Cretan coins from Knossos, of the first few centuries BC, the famous "Cretan" maze.

Chapter V

The Camonica Valley site was used continuously from about 2000 BC. The Celts inherited the region early in the first millennium. With it they inherited the symbol of the maze. Janet Bord describes the carvings:

> "The oldest carvings date from the Neolithic period, and the changes in the style show that carving was continued up to the Roman conquest. Labyrinth designs occur frequently. Some incorporate figures or faces at the centre, or just two dots to represent eyes – perhaps showing a monster as an integral part of the labyrinth."

Fig. 34 Maze Patterns from Camonica Valley.

a

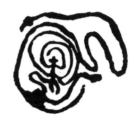

b

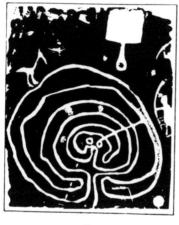

c

a Spiral with eyes.
b Hero fighting monster.
c Labyrinth with eyes.

Fig. 35 Coins from Knossos, Crete, c. 300 BC.

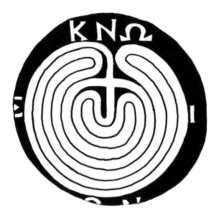

a Circular form.

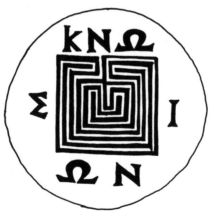

b Square form.

Fig. 36 "Cretan Style" Maze, Camonica Valley, Alps.

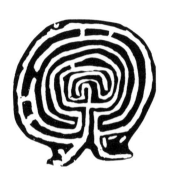

"Later designs show Greek in-
fluence, and the Cretan-style
labyrinth shown here is dated
to around 300 BC. The others are
roughly dated to the third or
second millennium"
~Janet Bord.

[75]

Chapter V

In Bord's summary, only one Camonica Valley maze matches that on the coins from Knossos, the so-called "Cretan style". But such coins only circulated from about 300 BC. Apart from this one exception, the rest of the mazes are supposed to thousands of years older, in the context of "Neolithic" petroglyphs. It is as if a passerby in Roman times with a shining new Cretan coin noticed the 2000-year-old failure to "evolve" the Cretan maze, and so pecked out the Classic model.

There is, however, a second maze, one with eyes, that seems *almost* Cretan, if in a more archaic style. The feet of a bird mark one corner of the maze, the path of an arrow cuts the other, in a half-diagonal line.

Fig. 37 Labyrinth with eyes, Camonica Valley.

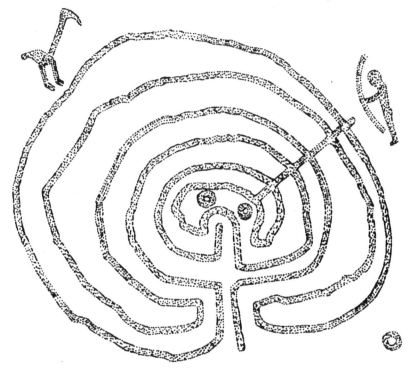

This is the basic maze in line / path reversal; the path is picked out. The arrow pierces one "eye" of the maze.

Fig. 38 Path-Line Reversal.

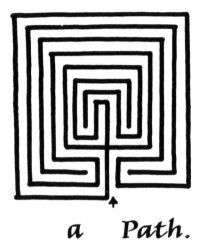

a Path.

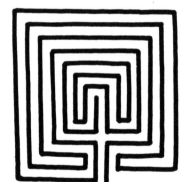

b Line.

The Camonica Valley maze with eyes, *fig.* 37, differs from the Cretan, not just because it has eyes, but because of its line-path reversal. It has been drawn on the rock by someone who knows the secret of the construction of the basic maze, drawn quite freely beforehand; the path has then been pecked into the surface between the lines, like a maze cut out of turf. The path is therefore a channel you can trace with your finger. The "monster" eyes at the centre of this maze are therefore on the line, not the path. We are in no danger of meeting the Cretan Minotaur *en route* to the centre of the Celtic maze. We tread a different maze here; we must seek the clue to this maze in another yarn entirely!

Chapter V

Fig. 39 Horned Figure and
Serpent, Val Camonica.

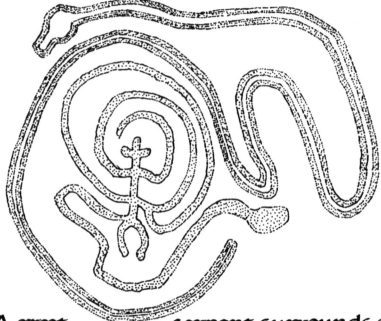

A great serpent surrounds a
horned figure around whose waist one
snake is coiled, and from which one
darts out. A clue to the Celtic tradit-
ion behind this carving is found in
the Old Ulster tale, the Raid of
Fraech's Cattle.

[80]

The Raid of Fraech's Cattle tells how
the hero Conall Cernach helps Fraech
rescue the magic cows that Boand gave to
him. The action takes place in the **Alps**.
There, a milk maid warns them of a
giant serpent that guards the warriors
who stole the cows: "The worst thing
for you is the serpent at the fort. Many
tribes are thrown to it." She opens the
place to them at night, while the guards
sleep. As the heroes proceed to destroy
the compound, "the serpent makes
a dart *into the waist belt of Conall
Cernach*", who plunders its treasure
and releases Freach's cows. "And Conall
lets the serpent out of his belt," ends
the tale, " and neither has done harm
to the other."

[81]

Chapter V

Anne Ross discusses the tale's anticlimactic - by Greek standards - ending.

" The non-aggressive coming together of the great warrior-ancestor Conall Cernach, and the mighty treasure-guarding serpent, protector of warriors, guardian of the fortress, suggests an earlier and traditional relationship between the hero and serpents."

The way the snake coils round Cernach's waist as if it knew him suggests the ancestor deity of Gaul, Cernunnos. He is portrayed with ram-headed snakes round his waist in France. His earliest cult centre is the Val Camonica.

Fig. 40 Camonica Valley,
 Cernunnos.

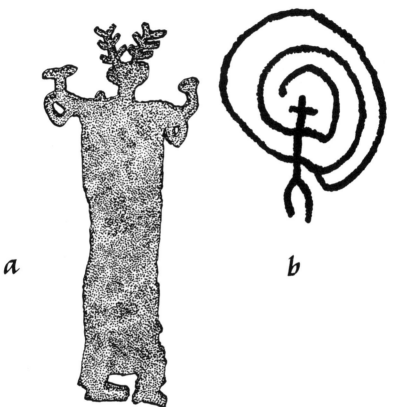

a

b

a Cernunnos petroglyph
b Horned figure with snake
 passing through its waist.

Fig. 41 Maze from Figure with Serpent through Waist.

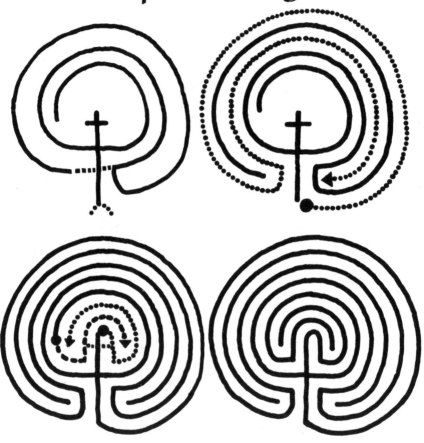

A spiral passes through the stick-man's middle, as in the tale, "the serpent makes a dart into the waist belt of Conall Cernach". If we erase the part where it crosses his waist, the serpent "slips out from the waist belt", and both are intact. But the fort is destroyed. To construct it, take a line from the foot of the figure, round the outside, through the gap, and on inside. We have entered the fort! Then produce the top of the figure down and round to end alongside the end of the spiral, and bring the end of the spiral back in the opposite direction, using the horns as guides. Then erase the horns – remove Conall Cernach – and you have the fortress of the mighty serpent of Val Camonica : the basic maze.

[85]

Fig. 42 Maze from Ocular Spiral.

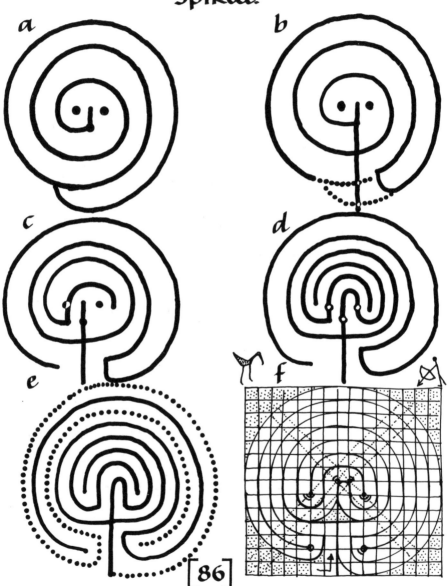

I call this method piercing the head of the serpent: starting with the single ocular spiral of Val Camonica, *fig.42a*, break where tail touches previous coil so that the serpent turns back on itself, *b*; through this gap, pierce the head of the serpent, *c*; and, cutting the neck, bring it over the spearhead and beyond the right eye, *c*; from the tip of this spear, bend a line into a shepherd's crook, through the right eye, a loop back to the left, *d*; draw line from butt of spear, around and into finish, once again, the basic maze, *e*; The same proposition in geometric terms; compare *figs 42f*, and 37: the crane's feet point out the two diagonals at the left corner; the archer accounts for the additional one, right.

Chapter V

The Celts of Camonica Valley, then, were well acquainted with the maze. Rather than one, late, Greek-influenced model in the "correct" form among a lot of "primitive" ones groping towards the ideal, in fact the older ones turn out to be clues to construct that same maze. The Celts linked it to their own mythology of horned god and snakes: at least the four examples we have seen were put in the Alpine sanctary of the Stag God, Cernunnos. The serpent coiled about the god's waist – Cernach's waist belt – is used as a memory aid to construct the maze. If the Alpine Celts had received the maze from Greece, they would show the minotaur; if from Rome, they would show the Trojan horse.

[88]

Fig. 43 Freehand Construction of the Basic Maze.

Step-by-step method.

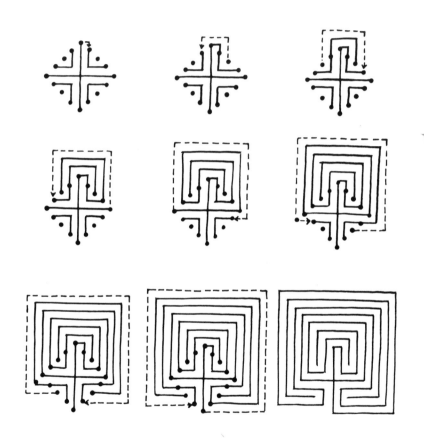

Fig. 44 Square Grid Construction of Basic Maze.

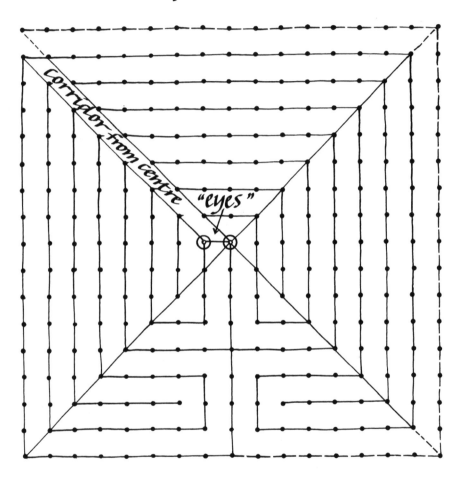

The Camonica Valley Maze
Fig. 45　The Secret Entrance of the Maze.

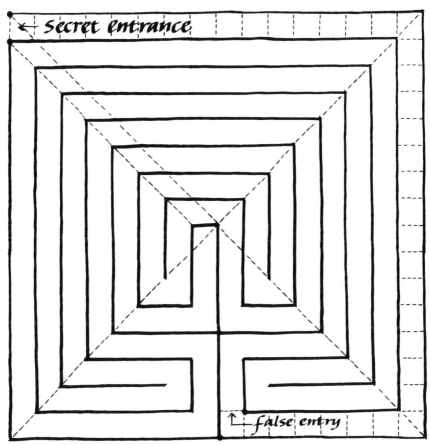

Chapter V

The square grid explains the two "eyes" of the mazes at Val Camonica. One is the true centre of the implied 16 x 16 square. The other, false, centre indicates the first step of the maze construction. The fact that the maze is truly centred on the 16^2 grid means its true form was a guarded secret at Val Camonica. The basic maze, as circulated from 1200 BC in Greece, is incomplete, with the entrance at centre base. In the Val Camonica maze, the location of the true exit is indicated by the attendant crane, or similar bird sacred to the goddess. The justified, squared form provides a line around the three corners of the square, providing a corridor of egress cutting through the coils, the walls, to salvation.

○ The completed, square maze
sheds light on the myth of the Cretan
maze, where Ariadne gives Theseus
a ball of thread with instructions to
first tie one end to a post *outside*
the labyrinth. This makes no sense
if applied to the form of the "Cretan"
maze, since, being monocursal, it
is impossible to get lost in it. But
if we take the "clew" or thread to be
a line which, tied to the corners of
the square, establishes a gate post
at the true entrance, and likewise
a half-diagonal corridor or return
passage from centre to exit, then
the plan of the cunning craftsman,
Dædalus, reveals the way out of the
lair of the Minotaur.

Fig. 46 Bull's Head as sign of Womb.

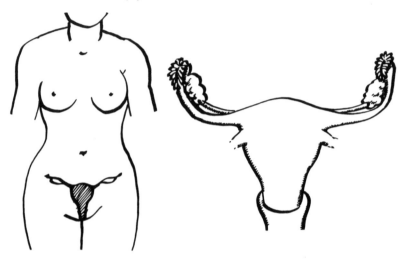

We have seen how the maze is tied to the journey of birth and the path of rebirth. But why the link with the bull ? The bull may have become associated with the goddess because the womb resembles the shape of a bull's head, the fallopian tubes extending either side, like horns.

Fig. 47 Tau-Rho Monogram
in maze.

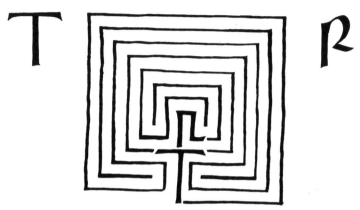

The Greeks, however, probably
saw the letters *Tau-Rho*, T-R, in
the maze: *tauros*, bull.

Celtic, Greek and Latin words for
bull, *tarbh, tauros, taurus*, all contain
the Indo-European root sound T-R.
The root in India refers to "going
through, across, delivery", close to
Latin, *trans*, across. The bull, a
draught-animal, may be associated

with T-R words expressing passage, as
*train, trail, trace, track, traffic, trek,
travel, trudge, truck,* which apply to
land, *Terra*, which is passed through
as *terrain, territory, terrace, tract*; the
maze itself is suggested as enclosure,
trap, delivery from which is *triumph*
celebrated by dancing through the
maze, as in T-R words *traipse, tramp,
tread, trip, trot, turn* (from Celt. root,
tro, turn, revolve). The maze is named
Trojborg, Trojburg, Troia, or Walls
of *Troy.* Janet Bord cites Jackson
that, "Homer's Troy and all the
other Troys were called after the
word used for mazes." This word, I
believe, stems from a root that
meant birth, "delivery", and salva-
tion, "deliverance".

DRAWING CELTIC MAZES FREEHAND

HE ACT OF DRAWING maze patterns is also a dance of line across surface. Now is the time to get pen and paper and try your hand. They can be reduced to dot grids, and it is worthwhile to analyse the pattern on the grid. But to start with, try doing them freehand. They can be as rough as you like, so long as their construction is sound. *Bon voyage* .

Fig. 48 From Pen-Arthur, Wales.

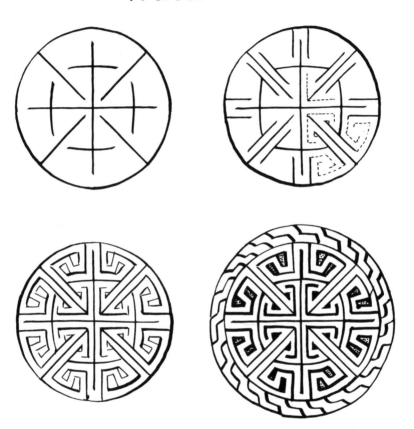

From recumbent cross-slab.

Fig. 49 Aberlemno, Scotland.

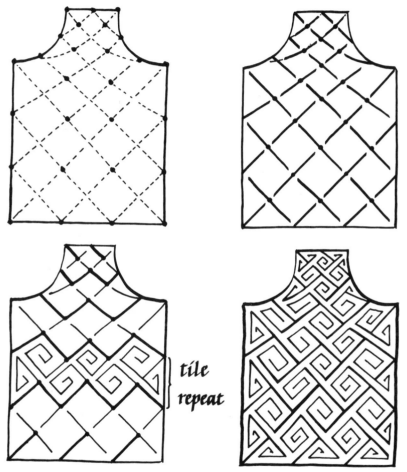

tile
repeat

From arm of standing cross-slab.

Fig. 50 St Madoes, Scotland.

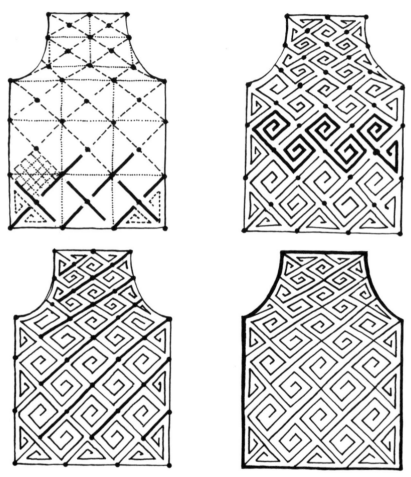

Arm of standing cross-slab.

Fig. 51 Golden Grove, Wales.

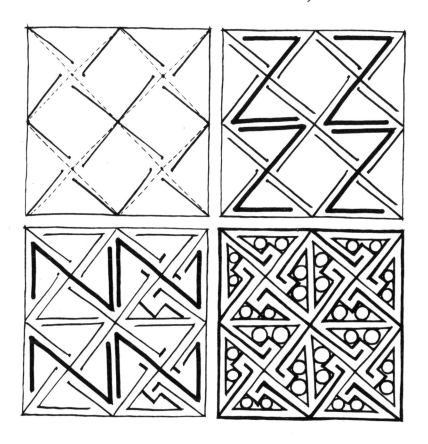

From cross-shaft.

Fig. 52 Penmon, Anglesey, Wales.

From cross-shaft.

Drawing Celtic Mazes Freehand
Fig. 53 Nevern, Pembroke-shire, Scotland.

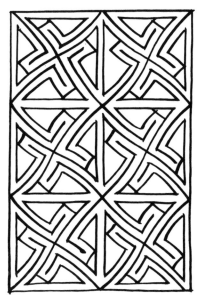

Fig. 54 Aberlady, Scotland.

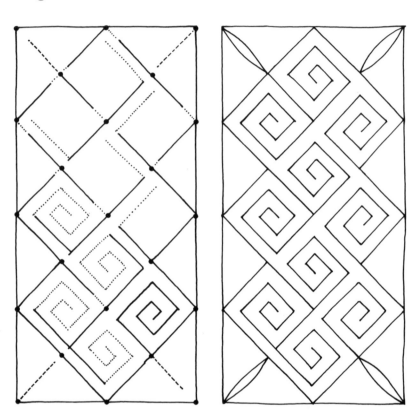

Cross-shaft.

Fig. 55　Rosemarkie, Ross-shire, Scotland.

Cross-slab.

Fig. 56 Abercorn, West Lothian, Scotland.

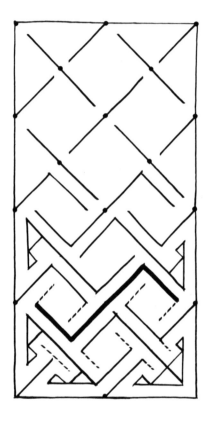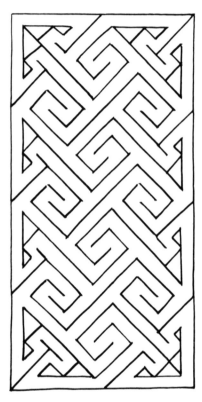

Drawing Celtic Mazes Freehand

Fig. 57 St Andrews, Fife.

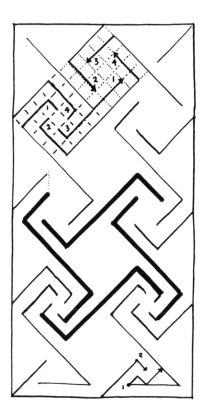
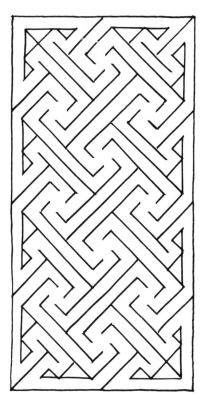

Fig. 58 Collieburn, Sutherland, Scotland.

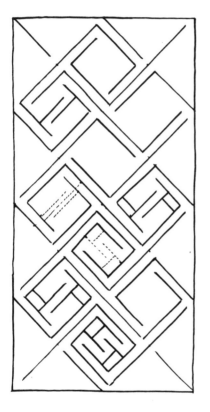 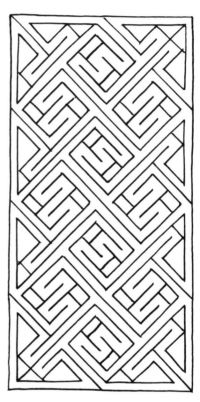

Fig. 59 Rosemarkie, Scotland, detail.

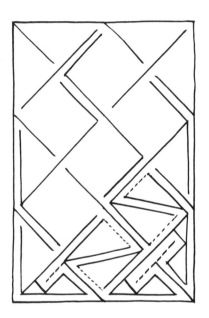
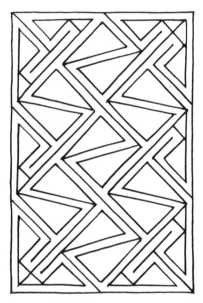

Fig. 60 Farr, Sutherland, Scotland, detail.

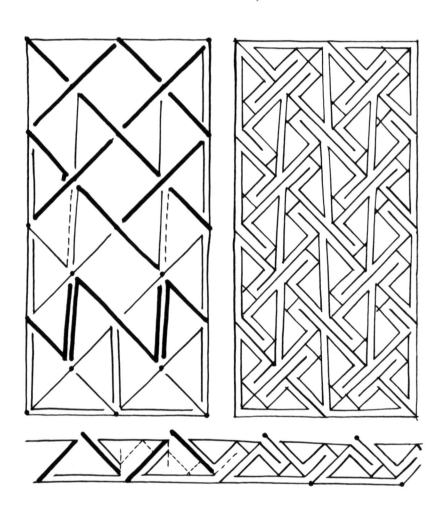

Fig. 61 Gattonside, Roxburgh, Scotland, detail.

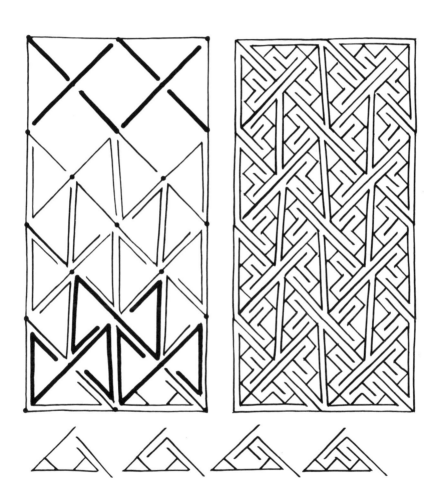

Chapter VI

Fig. 62 Nigg, Ross-shire, detail.

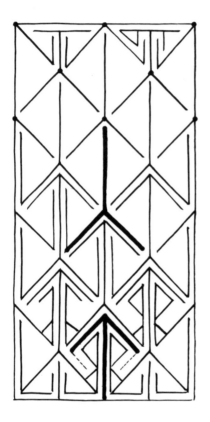
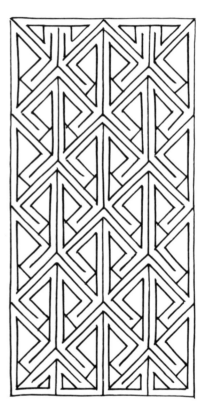

A COLLECTION
OF
MAZE PATTERNS

N THE FOLLOWING PAGES
I explore the wide variety
of different maze pat-
terns such as were
collected by James Romilly Allen
in the last century. I follow his
repertory for the most part in my
selection, adding notes on the
construction. In general I use
the freehand method as in the
last chapter. It is also a good idea
to work out the pattern on a
square grid, then do it freehand.

[113]

Fig. 63 Single Border Patterns.

a

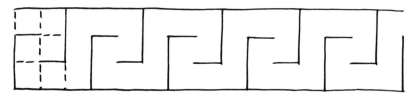

b

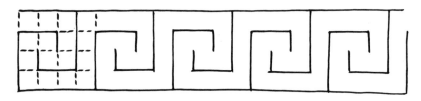

c

A Collection of Maze Patterns

Fig. 64 Single Border Patterns.

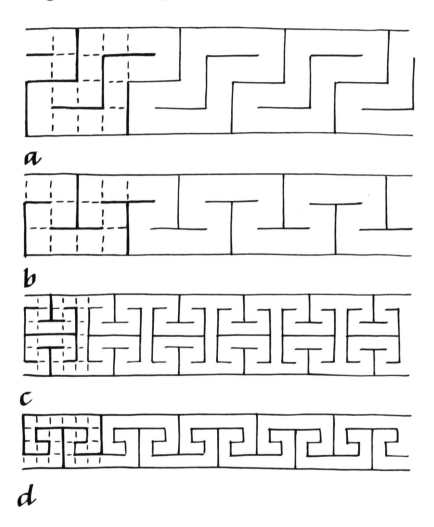

a

b

c

d

Fig. 65 St Gall, Switzerland.

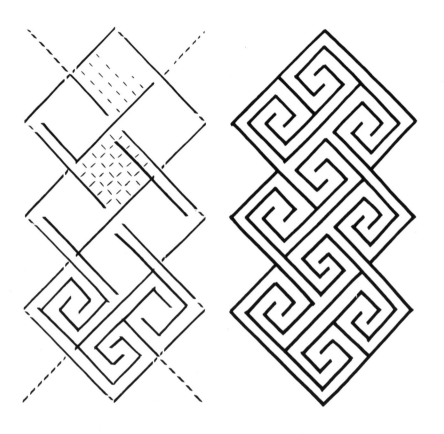

Diagonal grid panel.

Fig. 66 St Gall, Switzerland.

Diagonal grid, continuous line.

Fíg. 67 Panel from Book of Durrow, Ireland.

Diagonal panel, continuous line.

Fig. 68 Book of Lindisfarne, England.

(corner variations)

Fíg. 69 Tíle Repeat Desígn.

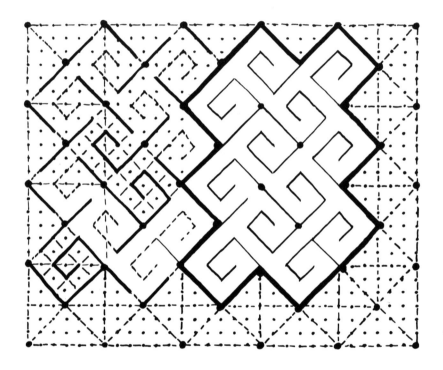

Panel of single spirals set on diagonal grid.

A Collection of Maze Patterns

The tile design opposite begs for application. Its popularity is attested by the list prepared by Romilly Allen; it was found by him at *Maidenstone, Chapel o'Garioch, Nigg, Golspie, Farr, Kirriemuir, Kingoldrum, St Vigeans, Inchbrayock, Aberlemno, Monifieth, Mugdrum, St Andrews, St Madoes, Fowlis Wester, Meigle, Dunkeld, Eilanmore, Rosemarkie, Abercorn, Canna, Silian, Killamery, Monasterboice;* and with many more and finer lines, in *the Books of Durrow, Kells and Mac Durnan.*

Fig. 70 Book of Mac Durnan, Ireland, border.

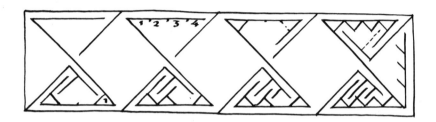

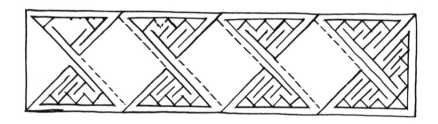

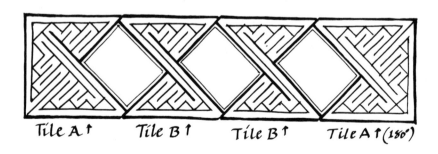

Tile A ↑ Tile B ↑ Tile B ↑ Tile A ↑ (180°)

Fig. 71 Book of Mac Durnan, Ireland, border.

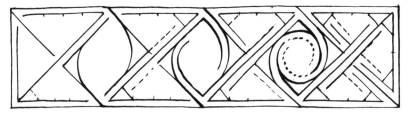

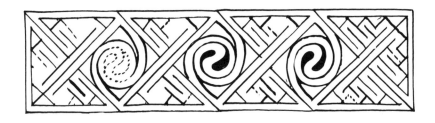

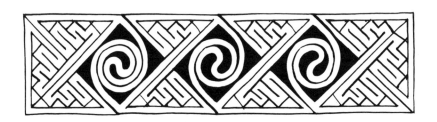

Border with curved double spirals.

Fig. 72 St Gall, border.

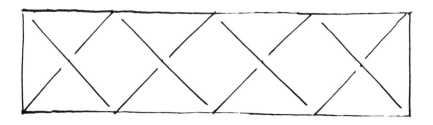

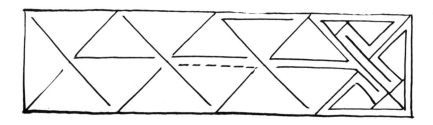

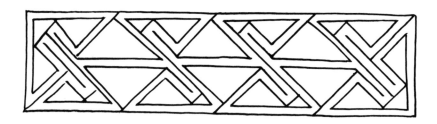

Fig. 73 St Gall, border.

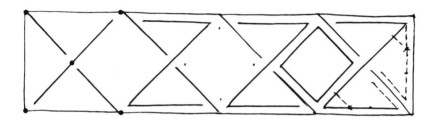

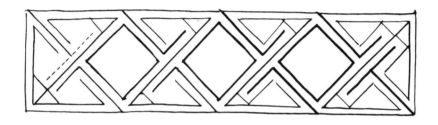

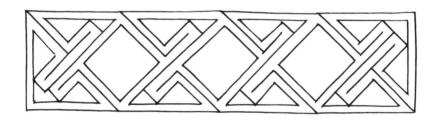

Lozenge insets; compare fig. 70.

Fig. 74 Norham, Northumberland, border.

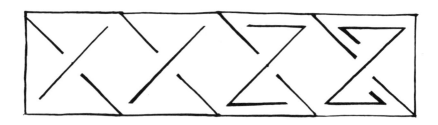

(Minimal Triangle Treatment).

Fig. 75 Meigle, Perthshire, Scotland, border.

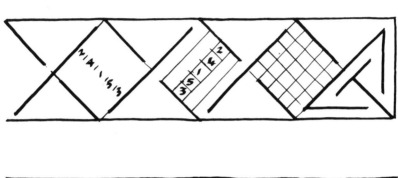

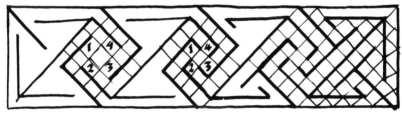

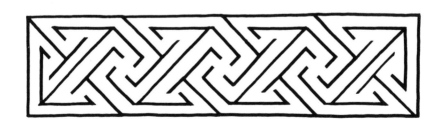

Fig. 76 Codex Aureus, England, border.

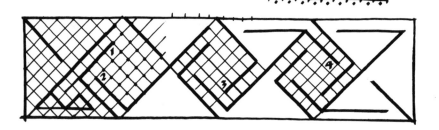

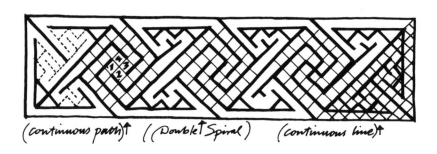

(continuous path)↑ ((Double↑Spiral) (continuous line)↑

Fig. 77 Rosemarkie, Ross - shire, border.

fig. 78 St Andrews, border.

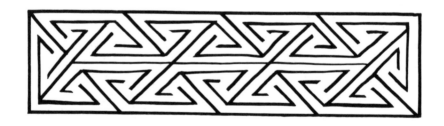

A Collection of Maze Patterns
Fig. 79 Domnach Airgid
Metal Casket, border.

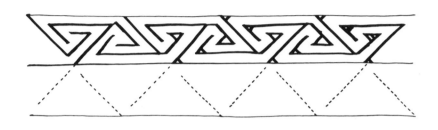

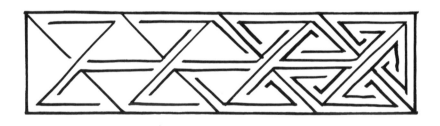

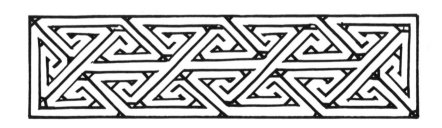

Fig. 80 Clonmacnoise, Ireland, border.

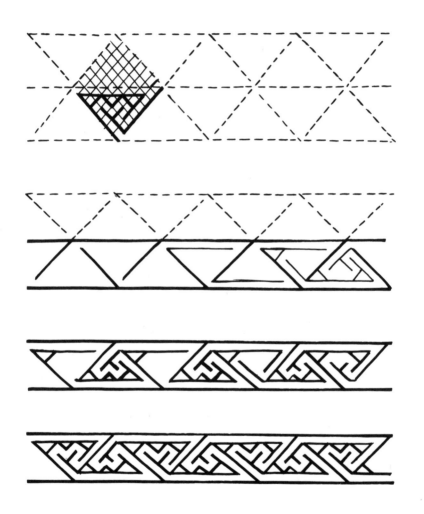

Fig. 81 Biblia Gregoriana, border.

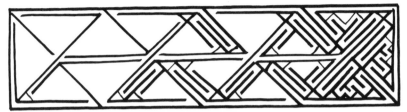

Ms. Brit. Mus. Biblia Gregoriana,

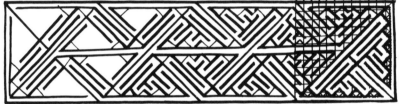

Bibl. Reg. 1.E. vi.

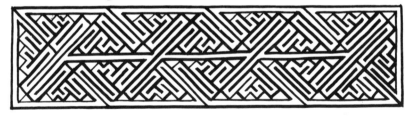

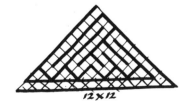

12 x 12

Fig. 82 Book of Chad, Wales, border.

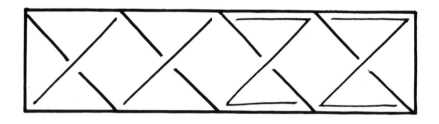

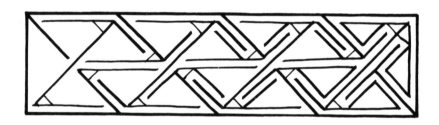

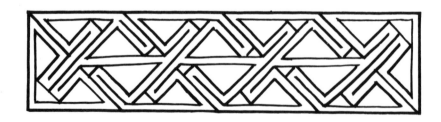

A Collection of Maze Patterns

Fig. 83 Inchcolm, border.

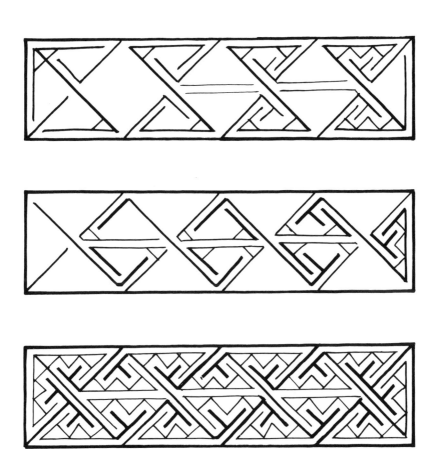

Fig. 84 Shandwick, Scotland, panel.

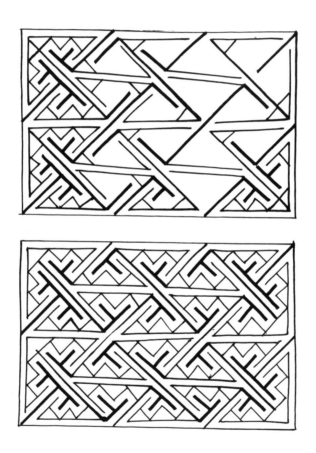

Fig. 85 Book of Mac Regol, Ireland, panel.

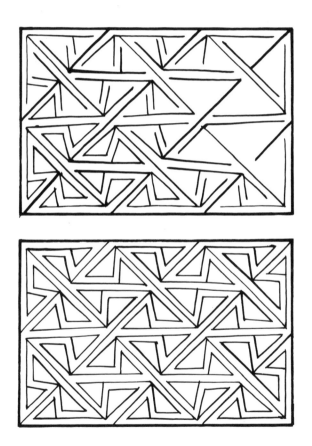

Fig. 86 Nigg, Scotland, border.

 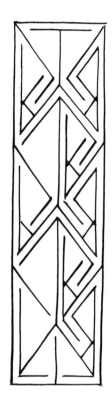 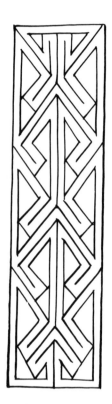

Fig. 87 Book of Kells, border.

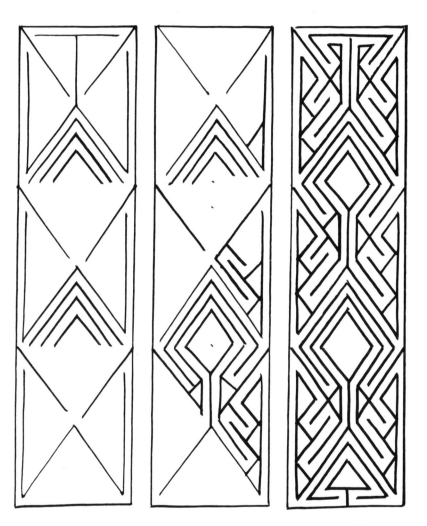

Fig. 88 Book of Kells, unit.

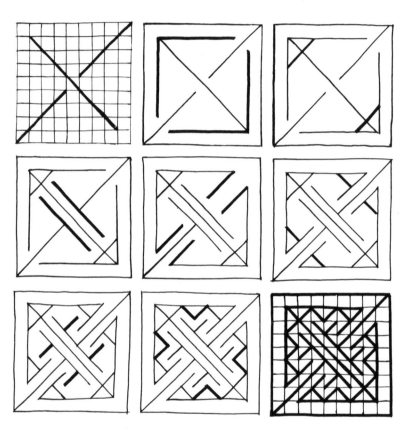

This pattern joins all the dots of a 9×9 grid.

Fig. 89 Mac Durnan, unit.

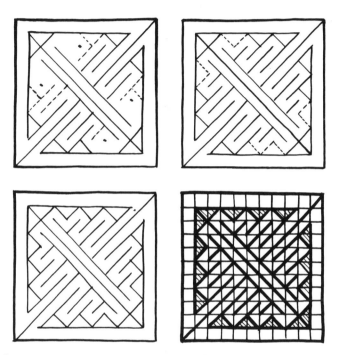

This pattern joins all the dots of a 11x11 grid.

Fig. 90 St Gall Penitentiale, unit.

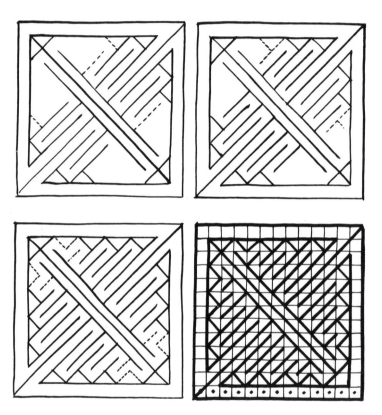

13 × 13

Fig. 91 Dupplin Castle, Scotland, unit.

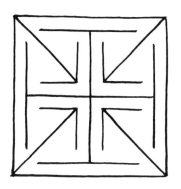

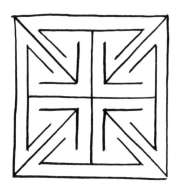

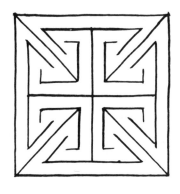

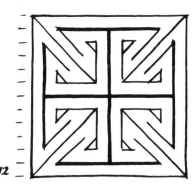

12 x 12

Fig. 92 Mac Durnan, unit.

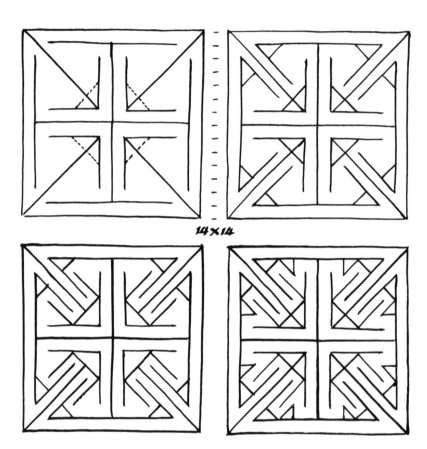

14 × 14

Fig. 93 St Gall Penitentiale, unit.

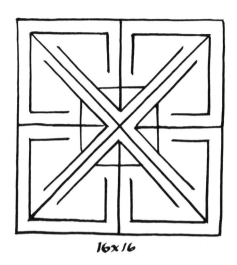

16 x 16

Fig. 94 Mac Durnan, unit.

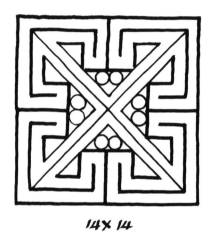

14 X 14

Fig. 95 Alnmouth, Northumberland, unit.

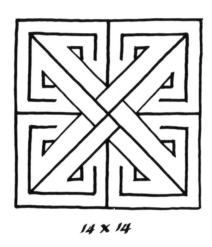

14 x 14

Fig. 96 Invergowrie, Scotland, unit.

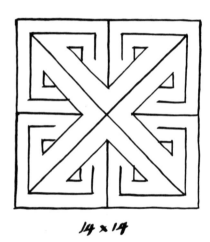

14 x 14

Fig. 97 St Andrews, unit.

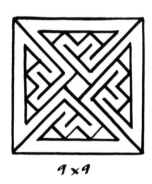

9 x 9

Fiᵹ. 98 Mac Durnan, circle.

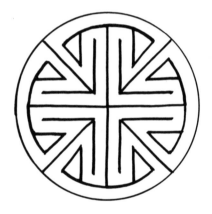

Fig. 99 Kells, circle.

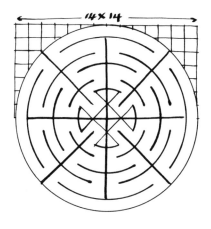

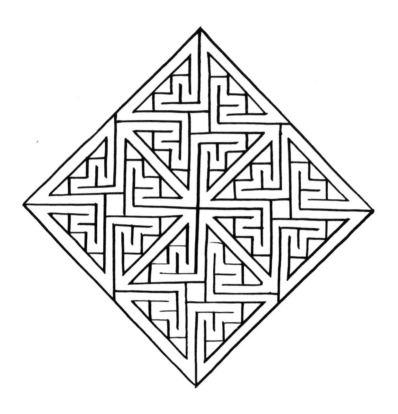

GLOSSARY

BAR CHEVRON: a chevron of two parallel lines instead of one.

BAR CHEVRON POINT TO POINT:

BAR CHEVRON POINTS APART:

BAR LATTICE:

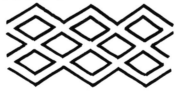

BAR SALTIRE:

BAR ZIGZAG:

CAIRN: a pile of rocks raised to a point as a marker of a site of significance, such as a grave.

CHEVRON: three points joined by two lines, as two sides of a triangle.

CONCENTRICALLY: having the same centre.

"CRETAN~STYLE" MAZE: the form of maze adopted by the ruling house of Knossos as a royal crest and used on Cretan coins of the second century, BC.

CROMAGNON : the people who spread through the world after the Ice Age, from 35,000 – 8000 BC. Known as Advanced Hunters, they have been named after the site in France where archaeologists first discovered their existence.
CROSSHATCH: to shade with crossed or parallel lines.
CROSS-SHAFT: in Celtic crosses of the upright sort, the lower portion below the ring of the cross and above the base.
CROSS–SLAB: a flat slab, with a cross carved on one side, and pattern on the reverse; raised as a marker in Pictland, elsewhere laid flat, or "recumbent".

"EAR OF CORN":

"FIR TREE":

FRET: a pattern cut out of a surface of wood, metal, etc., so that light may pass through.

HERRINGBONE:

KEY PATTERN: the name used by Romilly Allen to describe Celtic maze patterns.

LABYRINTH: a maze.

LABRYS: the double-axe, or butterfly emblem of the Goddess.

LOZENGE:

MEANDER:

MEGALITHIC: literally, "great stone", referring to the culture of the third-to-second millennium BC on the Atlantic seaboard of Europe.

MONOCURSAL: having just one path, as in the basic maze.

NEOLITHIC: the Late Stone, or "New Stone" Age, being advanced hunters and early farmers before the coming of metal work.

Appendix

OCULAR SPIRAL : a spiral with two eyes or a face in the centre.
PETROGLYPH : an engraved symbol or picture carved on rock.
SALTIRE : the diagonal cross; X.
SALTIRE GRID :

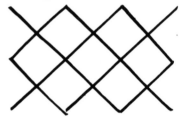

SALTIRE TILE :